Poetically Speaking: Finding Life Through Words

Poems By:
Jerica E. Crawford

Poetically Speaking: Finding Life Through Words

This book includes a mix of fiction and nonfiction. Unless otherwise noted, all scripture quotations are from The New King James Version of the Holy Bible.

2013

Copyright by Jerica Crawford

All Rights Reserved

Printed in the United States of America

Cover Design by Antwone Whiteside at Graphics United
Photographs by Joshua Mitchell at Jolemi Productions

bBold Publications
P.O. Box 11562
Merrillville, IN
877-242-1574
www.dymeatab.com

ISBN-13:978-1484877258
ISBN-10:148487725X

All rights reserved under International Copyright Law. Contents and/or cover may not be reproduced in whole, or in part, in any form or by any means without the expressed written consent of the Publisher.

Contents

Rejected 'Cause I'm Saved	5
Psalm 51 & More	6
Everything I Need	8
The Black Woman	9
Mom	11
My Brother's Imprisonment	13-14
Looks Are Deceiving	15
Their Loss: Be Better Than They Were	16
Sister to Brother	17
Tattoo	19
Off On Your Own	21
Commentary	22
Master of Abuse	23
The Makeup Bag	24
The Pastor's Son	26
Commentary	27
The Price of Success	28
Ambition	29
The Room of Remoteness	30
It Can Happen For You	31
No Limits: Endless Possibilities	32
Commentary	33
Christmas Sucks	35
Refund Checks	36
Calling Forth Financial Increase	37
Commentary	38
The N-Word	39-40
Commentary	41
The Complexion Battle	43

Commentary	44-45
Thieves in the Night	46
What Is Justice?	47
Commentary	48
Sensational Dancer	49-50
Live Now & Be Grateful	52
Funeral (Transformation)	53
Commentary	54
Long Distance Doesn't Work	55
Can You Keep A Secret?	56
Cheater	58
Love	59
Dreamer	61
With Him	62
What Love Costs	63
Commentary	64
Too Cool	65
Chance of Rain	66
Loneliness, Distance, & Depression	67
Insomnia	68
Commentary	69
In the Event of My Death	71
Life Is Good	72
Acknowledgements	74
Advice to Poets	77

"Write the things which you have seen, and the things which are, and the things which will take place after this."
-Revelation 1:19 Holy Bible, New King James Version

Rejected 'Cause I'm Saved

He approached me so slick and smooth.
He blocked my way so that I could not move.

He threw a little line on me.
He told me we were meant to be.

I laughed and told him to get out of my way.
He said, "I can't 'cause you've been running through my mind all day."

So I asked him, "What do you want in life?"
He said, "I want you to be my wife."

I asked him, "Are you saved?"
That's when he turned around, started walking,
looked back and waved!

Psalms 51 & More

Create in me a clean heart, O' God
and renew a steadfast spirit within me.
Do not cast me away from your presence,
and do not take your Holy Spirit away.
Restore to me the joy of my salvation
and uphold me by your generous spirit.

The pains of this world have broken my spirit
and demons torment my mind all day long Lord.
I grieve for the loss of my salvation
because it no longer exists within me,
and without faith, I fail to push the devil away,
so he's flooding me with his evil presence.

My past has scarred me and I don't enjoy the present.
Many unpleasant memories consume my spirit
and I feel lost and alone like a runway.
My sins are countless and longing for a Savior.
Please accept my repentance and wash me
as white as snow. Retrieve my stolen salvation.

Do not let me become blind to the beauty of salvation,
but restore to me the awe of being in your presence.
Retrieve my soul and rekindle the fire within me
and allow me to worship you in truth and spirit.
Heed to my voice when I cry out, "Abba Father"
and remove all mountains when they come my way.

Through all the temptations and trials, make a way
of escape and let me not be ashamed of my salvation.
Let me remember the sacrifices of Jesus
and the predestined resurrection of his body.
Cover me and strengthen me with might by His spirit
and expose His radiant light through me.

Deliver me from the destructive hands of my enemies
and make me victorious and immovable always.
In the place of fear, give me power, a sound mind, and
a spirit of love to witness to those who lack salvation
and bring back that reverence I once had in your
presence.

Let my testimony be, by His spirit, my salvation
was restored. He revived me. I was able to run away
from Satan's presence and God has proved, He is
Alpha and Omega!

Everything I Need

With everything you have to tend to,
I'm still the apple of your eye and you
are mindful of my needs and remain true.

I can always feel you near me, guiding
me through my tests and trials and wiping
my tears. You prevent my feet from sliding.

Your favor and mercy works in my life
daily, over flooding me with blessings
and keeping me from all danger and strife.

When I lie awake at night worrying
you bring peace to my mind and hope to everything that seems too hard and discouraging.

Your awesome love brings out the best in me
and although I don't know the plans you have
in store, I know you're everything I need.

The Black Woman

The black woman is far from basic.
There is no description or definition
that properly explains her. She walks
her own path with a mean strut,
but doesn't mind pausing to help others.
She is a trendsetter.

The black woman is self-sufficient.
She depends on no one, yet everyone depends
on her. With only 2 hands, she outperforms
as if she has 10, making miracles
that often lead people to wonder.

The black woman is a caretaker.
No selfish bone resides in her body.
She provides to everyone in need
and often plays the role of mommy and daddy.
Family is her most prized possession and
there are no risks she won't take to protect them.

The black woman is like the energizer bunny.
She just keeps going and going, even when
trials come, she doesn't get side-tracked by
pity parties. Rarely does she cry or worry
and if so, she won't let it be known or seen.

The black woman holds her head high at all times,
displaying her magnificent beauty. Nothing looks

as good as her smile and you'd think she only
has eyes for you. Her style is impeccable.
She can rock her hair straight, with weave, or go
natural.
She is not limited; therefore, she is not typical.

The black woman knows God. Her lips
bring forth His praise daily and His word is
stamped on her heart. Because of Him, she knows
who she is and won't be told anything different.
She is an extraordinary, powerful, divine
Black Woman.

Mom

As I look at myself in the mirror,
another lady stares back at me.
43 years of age, still with a timeless beauty.
She stands tall with the eyes of experience,
the hairs of wisdom and the mouth of discernment.
Her hands are hard-working and everything
she owns, she has rightfully earned it.
With grace and dignity I've watched her fight
through some of her toughest moments
and still come out, hands lifted in praise,
looking refined
and polished.
She is a strong woman
and personally; my angel,
my inspiration,
my blessing.
She is my mom and I see her through
my reflection because she is the type of woman
I strive to be.

My Brother's Imprisonment

I remember how it felt to see you.
A smile of pity ran across my face
as you entered, dressed in all navy blue.

Hugging you was like hugging a stranger.
Were you still my older brother or
a person who could pose a danger?

I tried to suppress the uncertainties
as you asked me about my college life,
but what to ask you? Locked up with no keys.

You've been absent for many special things;
one being, the birth of your niece. She has
become the family's crowned little queen.

I'm sure you'd love her if you ever met,
which brings me back to the fact that you're stuck
in here, your bondage I deeply regret.

How you got here, I was never informed.
Obviously you made an unwise choice
becoming a statistic the world scorns.

6451974-the number
that claims you; the number I put after
your name when I write. I often wonder

who bears the numbers before and after
yours? Do their families come to visit?
Or have their lives been terribly shattered?

I guess their lives don't really matter,
but what do I do with you being here? How
do I stay strong and keep the faith in what

I do not see? Your presence is missed and
I just want you home with the family.
The thought of you in jail I cannot stand!

However, me being distressed and down
will not make the situation better,
so I pray that one day you'll be around.

Looks Are Deceiving

Please, do NOT be deceived
by this picture you see.
For some reason, I have it framed
in my room, on my desk,
but it doesn't mean that much to me.

It's a picture from my high school
graduation-June 4, 2008.
My dad has one arm around me,
looking at the camera smiling,
and I am standing there in my gold cap and gown
kissing him on the cheek.

We look so happy, like a father and daughter
who have always been close,
but the truth is, I have never known him.
He hasn't been there for me,
and now that I'm a junior in college,
I'm done trying to grant him that opportunity.

Their Loss: Be Better Than They Were

I cried many nights for my absent father
but you went without a mother. I don't know
the whole story and I won't bother, but the
thought of you having that void hurts me so.

I can't imagine why anyone wouldn't
want to be near you. Your presence is a gift
and not having it would leave me wounded;
desolate. Sometimes I wonder if she

will ever know the impact of her neglect,
like the night you cried and I hugged you tightly.
I wanted to kiss your tears and vow to protect
your heart and tell you, you turned out nicely

without her. I wanted to tell you despite
her lack of love, you've treated me like a queen
and you're an amazing man who makes me light
up and avoid sleep because you are my dream.

See I can relate to your pain because I
felt it not knowing my father but it's their loss
and all we can do is try to satisfy
ourselves by being better than they were.

Sister to Brother
Inspired by Langston Hughes,' "Mother to Son"

Lil' bro, I must tell you:
Life isn't meant to be easy.
There's supposed to be bumps
in the road, potholes, and detours;
dark valleys and rollercoasters
that make you queasy
as well as interrupted plans and long suffering
but that doesn't mean
that you take the backseat.
No, that doesn't mean you give up
and let others live your dreams.
So work hard lil' bro.
Don't you become an idle adult
who can't stand on his own.
Don't let your life
or our mother's work
be in vain and remember
that God always makes a way
but life isn't meant to be easy.

Tattoo

It was meant to honor her mother and father-
a rose with their names flowing in banners.
It sat on her right shoulder
where needles tickled through
and itching occurred long after.
She was happy when she first got it,
satisfied with her decision
because she equally loved them both
but on this day, as she walks
down the aisle at her wedding,
the tattoo is revealed
letting the world know who her parents are.
But only her mother is on her side
walking yet another mile
in her life and once again
taking the place of a father
who never really mattered.

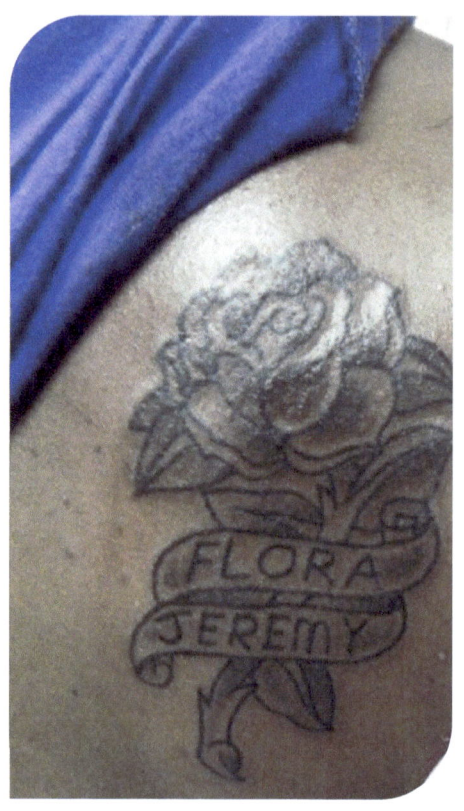

Off On Your Own

I remember teaching you how to ride your bike when you were five.
It was finally time to take the training wheels off and you were so happy.
After making sure your SpongeBob helmet was on tightly, I walked with you slowly while pushing your seat.
Finally letting go, you rode off in the distance leaving me.
All I could see was the back of your red shirt and your little legs pedaling.
I couldn't see your face, but I felt you were smiling.
I smiled too as I stood behind alone and you got further away.
You were going pretty fast and there must've been a rock or something on the sidewalk because you fell. I quickly ran over to help, frightened that you were hurt or crying and there you sat on the ground with your lips poked out and your hands across your chest.
Tears were falling from your eyes and your elbows and knees were bruised.
Even at that age you were stubborn and didn't want to move, so I stood over you for a minute with my head slightly titled and both hands on my hips, knowing that at some point I would reach out and you would accept, but eventually I would have to leave you.

Commentary:

My family is a key topic in my poetry because each and every member is important to me. I'm well aware that not everyone is blessed with a loving and supportive family, so I don't take it lightly. I'm very protective of my family and there isn't much I'm not willing to do for them.

My family has been a consistent source of unconditional love and they accept me just as I am. There is so much resilience, faith, and strength that we have as a unit and there is nothing that can tear us a part. I know this because we have God as our foundation.

I wrote about some of my family's experiences to encourage but also because I struggled to deal with them, so writing revealed my true feelings and made it easier to cope. Poems specifically about my father depicted how I felt at the time which was years ago. Since then, we have been in contact and it's been an amazing experience to get to know him and enjoy who he is and all the wisdom he has.

Master of Abuse

He parades around her like he's her master
calling her ugly and useless, telling her what to do;
making her fear and fret a potential disaster.

His hands hit her every day and even after
she strives to please him sexually. He continues to
parade around and pester her like he's her master.

Often he boasts and brags about being a pastor,
preaching about love and unity, but if the world knew
him to be a hypocrite, it would be his disaster.

He always overlooks my straight A's as if they don't
matter and my reward is cleaning his shoes until they
look brand new.
I swear if he vanished it wouldn't be a disaster.

My mother and I would pack up and move faster
than we normally do, covering our scars from abuse.
He'd parade around and pester the next one like he's
master, but hopefully she would escape before facing
disaster.

The Makeup Bag

They told her true beauty wasn't in a makeup bag,
but she kept her hands in it. She thought,
*"Maybe this concealer and mineral foundation can
cover my blemishes."*
So desperately she tried to hide
the flaws that her so-called man reminded her existed,
disguising the pain from the world even though
they already knew it.

Her voluminous mascara quickly gave length
and uplifted her eyelashes,
but did nothing for her torn down spirit.
Broken by broken promises, lies, and infidelity,
caking it on was her way through it.

Eyes popping from that gold eye shadow
and complimenting her skin tone too,
but it couldn't erase the bruises and scars
from the years of physical abuse.
His hands hit her so hard and had no regard
for her issues.

Her black eyeliner gave her eyes a nice outline
but failed to create a distraction from that black eye.
Nor could it count the many tears she'd cried
and never mind the many sleepless nights.

Maybe if she applied some lipstick she could smile
but that wouldn't silence all the words that had broken
her down and just then you might see her chipped
teeth that only heightened her insecurities
and made her feel like a beast rather than a beauty.

Her chocolate lip liner highlighted her luscious lips
but failed to reduce the swelling. See she was trying to
hide something others refused to pity.

They thought she had a good man and maybe she'd
upset him, so every now-and-then she deserved a
good beating.

What's worse is that there were children involved.
When they came home mommy was on the floor and
daddy gone. Even at a young age, they could sense
something was wrong. Like all black women she tried
to be strong. Her survival depended on him, or at least
she thought.

Fear prevented her from taking action and seeking
help and one day her pain was washed away
when he finally beat her to death.

The Pastor's Son

It's Sunday morning service and as usual
he's sitting in the first pew-
the area reserved for the pastor's family.
His black Armani suit is tailored specifically
for his husky frame and he's covered
in David Beckham's *Intimately*.
Caramel-skinned with hazel brown eyes,
full lips, and a pure white smile,
women flock to him like wild geese.
They dress seductively hoping to be seen.

The elders talk about his future success;
"He's sure to take after his father,"
"He quotes scripture perfectly,"
"And he's doing a wonderful job with the music
ministry," but they don't know he's not as great
as he seems, but a man full of deceit, a predator
seeking his prey in God's house lurking about
for the young and naïve.

I watch as he lures his next victim in;
Always after service while everyone's talking.
She's in her early twenties, tall and skinny
with long black hair falling down her back-
a pretty little thing. She stands in front of him blushing.
I shake my head in disgust, knowing he's about
to do it again; desperately wanting to say something.

But then the vision comes back of what he did to me.
I invited him to my small apartment, so he could hear
me sing. As I began Amazing Grace, he came up so fast
and attacked me. Like a wild beast he shoved me
and clawed off my clothing. Over and over I yelled
for him to stop, but he kept going. Since then
I haven't told a soul because he said
no one would believe me and I believe him.

Commentary:

"Master of Abuse," "The Makeup Bag," and "The Pastor's Son" are poems that kind of took a direction of their own. I knew I wanted to touch on some deep concepts such as abuse and rape but I wasn't sure how, so I just began writing and that's what came out. I will say, the movie, "Preacher's Kid" with Tank and Letoya Luckett did affect me and also situations I've seen others experience.

I am not saying that everyone is abusive or that you shouldn't trust people in the church. People experience horrible things that my poems allude to and they are often silent, or don't get help when they need it. I hope that poems like these bring awareness and a little more sensitivity to people's issues because you never know what a person has been through, or is going through.

The Price of Success

Blinds closed, lights dim, door locked; alone I sit
in this dark room in a wooden chair, trying to stay motivated
but *The Last Days of Socrates* and *Western Civ.* aren't keeping my interests.
What's the point in all this gibberish if in this dark room in a wooden chair, trying to stay motivated
I feel secluded from the wind and the sun?
What's the point in all this gibberish if
I don't have any friends to chit chat with?

I feel secluded from the wind and the sun.
I hear people outside laughing, and yet
I don't have any friends to chit-chat with.
They never told me this in the recruiting process.

I hear people outside laughing and yet,
The Last Days of Socrates and *Western Civ.* haven't kept my interests.
They never told me this in the recruiting process,
so blinds closed, lights dim, door locked; alone I sit.

Ambition

The weight of her book bag drags her shoulders down
a bit,
making her stop to adjust with every other step
but her feet still move swift,
weaving through the traffic of peers
and up the gray stairs
to the class called "success."
In a room with many who don't look
like her, she sits at her small desk
focused and ready,
eyes dilating as she looks at her test
because
she's studied all week and she knows this.
Within twenty minutes, she's aced it.
Leaving with confidence, she grins,
remembering that tests are all a part of the process
and not even they can interfere
with her ambition.

The Room of Remoteness

I live in the room of remoteness
contemplating my existence,
searching for my purpose,
and requesting God's assistance-
constantly trying to determine
how to leave an impact
on the soul of those who won't know me
while still keeping my dignity intact.

A young soul with an aged mind
secretly setting goals to make my name
great and still give God the glory.
Yes, that is my aim,
so I sit in the room of remoteness
writing these words with intense focus
in hopes of becoming someone
everyone will one day notice.

It Can Happen For You

Your dreams won't manifest
anytime soon if you
are consumed with fear
and negative people who tell you what you can't do.

You are equipped
just as every other individual
to rise from every obstacle,
become successful,
and do what may seem impossible.

There is nothing more annoying
than hearing excuses from talented people;
it is so disappointing.
You have to work even if it means making something
out of nothing.

Remember, it takes more than one try
and rejection is bound to occur
but that's no reason
to have your dreams deferred.

Keep going
even when it gets stressful because
you too, can become successful.

No Limits: Endless Possibilities

Climbing mountains of stereotypes;
treading through valleys of racism,
discrimination, and white privilege,
leaping over statistics and prevailing against ignorance;
I'm honored to stand among you
unwavering examples of resilience.

Through crying eyes and often times
a weary mind, you've maintained your momentum
and held on firmly to your vision,
allowing nothing to be a hindrance
and everything to be a lesson learned
for your continuance.

You've pressed toward your goal,
refusing to be boggled down by limits,
ignoring critics, choosing to utilize every minute
and approaching every task with an excellent spirit.
You've worked twice as hard,
knocking down barriers, increasing standards,
forcing others to get with it.

With commitment and integrity you've made an
imprint on this campus, proving on this day
that you are a worthy recipient
and today I acknowledge you with respect and
admiration, applauding your fearlessness,

reminding you that this is only the beginning and that your possibilities are endless.

Commentary:

"The Price of Success," "Ambition," "The Room of Remoteness", "It Can Happen For You," and "No Limits: Endless Possibilities" are poems that highlighted the pros and cons of trying to achieve various types of success. I remember writing "The Price of Success" for a class. The loneliness and frustration were things that I was feeling at the time. I was struggling to find a balance between my schoolwork and social life and it was weighing heavy on me. There were times where I felt like my work was pointless and I was missing out on my college experience.

"The Room of Remoteness" is where I began getting comfortable with isolation because I was more productive that way. For the most part, people understood this, so I was content. Each year got better as I learned different methods and strategies to manage my time. In this phase, I was also seeking God for answers concerning my purpose. Let's just say, I'm beginning to understand it.

"No Limits: Endless Possibilities" was a poem I wrote for an event on campus that honored multicultural students. I'm such a procrastinator, so I was writing the final draft backstage. I was so nervous while reading it that my hands and legs were shaking, but a lot of people enjoyed it.

To others who struggle to find a balance, always be selective about who and what you give your time to; get organized by making reminders, to-do list, and marking your calendar. Prioritize; never let anyone pressure you into doing something, always think for yourself and never get so money hungry that you neglect relationships that existed when you had nothing.

Christmas Sucks!

Colorful Christmas lights and red stockings are on display;
The tall green tree has plenty of gifts underneath
and smiles and laughter are flowing throughout the house,
but somehow the holiday spirit has not found me.

The giant green tree has plenty of gifts underneath
varying in size from enormous to pretty petite,
but somehow the holiday spirit has not found me.
Sadness has consumed me because as usual, I lack money.

Ranging in size from big to little, we're expecting
to have everything from jewelry to electronics,
but I'm not excited, more like sad because I have no money.
There are no gifts that say, From: Jerica under the tree.

Buying everything from jewelry to electronics would be nice
and smiles and laughter would surely fill the house,
but there are no gifts that say, From: Jerica beneath
the tree, so the Christmas cheer hasn't found me.

Refund Checks

Around August and January we're all in anticipation
of it, constantly calling financial aid and our banks
making sure we get it. It's the few times we receive
money without an occupation
and it's almost better than Christmas. We even stop to
give Him thanks.

But the tragedy is, we aren't wise in our spending.
We buy clothes, shoes, and flat-screen TVs, forgetting
to invest.
We're too focused on the present with our
transactions pending
and soon we return to being broke, asking others for
financial requests.

We must do better with these refund checks instead of
acting rich
because there's a future to prepare for and the more
we age,
the more responsibilities kick in, so it's time to ditch
the bad habits and repair the damages to prevent
being caged.

Calling Forth Financial Increase

I speak over this blue
Dooney and Burke wallet of mine.
On the outside it looks full and thick
but on the inside it's fairly empty-
with money that is.
Debit cards frequent negative balances
and the amounts on my gift cards
are so low I can't buy nothing.
I dread pulling it out during service
because I don't have enough
for my tithes and offerings,
but today I claim promotions,
financial blessings,
and I command money
to come forth from every direction.
I vow to never be broke again.
I thank God for a steady income
and for favor with men
who will start to bless me
and grant me opportunities
to make even more money.
I am debt-free and all my bills are paid.
Wealth and riches lives in my
household and I lack no good thing.
I thank God for prosperity
and I praise Him now because
he's bringing forth financial increase.

Commentary:

Finances are a critical part of everyone's life and it's something I've always struggled to manage. "Christmas Sucks" was written when I was immature in my thinking. I'd lost the true meaning of Christmas because I was so caught up in this idea of buying gifts. Whenever I couldn't buy my family gifts, I would get really depressed. Sometimes I bought them things even when they told me not to. I enjoyed being able to buy my family gifts and seeing their faces when they opened something but I was putting myself in a bind spending money I didn't have to spend.

I don't really believe that Christmas sucks, it's just a title. I actually enjoy the holiday and me and my family praise God and enjoy being around each other on that special day. There is no amount of money that can take the place of quality time.

"Refund Checks" was written my senior year in college. I don't remember what exactly made me write it but I laugh almost every time I read it. It is a serious poem, so to speak but I know there are a lot of college students who can relate to it and I think that's where the humor comes in. I wasn't always responsible with my refund checks or my school ID for that matter, since I could charge things with it, but because I'm getting older I'm examining my choices and starting to make changes to benefit me in the future.

I understand that God wants me to live an abundant life and not lack anything, so that's where "Calling Forth Financial Increase" comes in and I'm fully aware that once He gives me the increase, I have to make wise decisions or it's pointless.

The N-Word

I was born Negro, Spanish for "black."
 In Greek I was derived from the root word
 'necro'
 meaning dead. My negative connotation
 evolved over time
 from a misunderstanding. Because Egyptians
 practiced necromancy,
 Greeks thought they had an obsession with
 death
 and took those distorted beliefs back to Europe
 where they gave me a new meaning. The slave
 trade came
 and Africans were socially disadvantaged.
 They were perceived as second-class citizens,
 less than.
 Devalued and dehumanized because the
 darkness of their skin.

Forbidden to read and write, white masters
 strategically possessed their minds, making the
 idea

of ignorance actually become real. The task was to keep them
physically strong, but mentally weak and make the concept of freedom
seem like an impossibility. Then they changed me to nigger-
one of the most pejorative words any human being could speak,
gaining rank with others like coon, jigaboo, and pickaninny.

I produced hate, violence, and hostility while
generating stereotypes
that all black people were lazy, worthless, and thieves.
Slave owners used me so often they no longer knew the names
of their black slaves. With mention of me in literature, cartoons,
songs, and debates, I was quickly rising to fame.
Shockingly, African Americans decided to drop the –ER
from me and add an A.
Nigga. The excuse for its use was, *we mean it in a different way.*
Odious slur to some, to others friendly slang, but if white people said it,
it was an insult...how does that work?

So you see, my life has been full of controversy.
>A lot of people have tried to kill me and I don't blame them.
>I think about suicide a lot, but I know I will not easily die.
>I bring death, not life, chaos, not peace, division, not harmony.
>I hate my existence and I should've never been born.
>At this point, the only thing that will defeat me is the education of ignorant minds and a willingness to change
>things.

Commentary:

"The N-Word" was also a poem I wrote for a class but it was inspired by a specific event. My boyfriend at that time called me one day and he was explaining how his day went, like we normally did. He began telling me that he'd gotten into an argument with a Caucasian guy because he'd said the n-word. I can't remember if he called him the n-word, or if he just said it but my boyfriend was very upset. Being that I was never fond of the word, I decided to write a poem about it. I did a little research and reflected on how frequently I'd heard the word and in what circumstances, and "The N-Word" is what evolved.

I don't claim to know all the facts and my interpretation of the n-word's history may be wrong, but I do know the harmful effects of its usage. I don't find it okay for anyone to say and it's not a term of endearment but a word that carries and brings up a painful history every time it's spoken. I know not everyone thinks like me concerning this word and that's fine but my poetry is expressive and entails my subjective thoughts and feelings.

I'm not sure where the idea to have the n-word be the speaker of the poem came in but I think it's a unique perspective to take.

The Complexion Battle

The light-skinned vs. dark-skinned battle
has caused division between us black people
with many lighter ones receiving better treatment,
more opportunities in the workplace,
and acceptance from white people
and the darker ones being labeled as dirty,
ugly, and associated with animals.
Unfortunately this is causing an uproar, with some
feeling superior, others inferior
blocking us from the revelation that we are all
human beings, unique individuals
who should be equal.
See no matter what shade or complexion
we all have flaws but most importantly,
similar struggles and statistics
that we're trying to break through
and if we were to consider everything else
going on in the world, we'd see
that this is trivial.
Yes, I know the unfairness is visible
but wouldn't it be better to ban together
and make the difference?
I'm just confused as to how hating on each other
promotes progress.
Whether you're redbone, caramel, or chocolate
your value is priceless
and we're more alike than different,

more productive together than separated,
so I'm asking that we end this unnecessary battle,
eliminate another reason why we all can't get along
know that there's a difference between discrimination
and having a preference.
Let us not get so caught up in this
that it leads to entertainment for
other races.
Stop to think before you make offensive statements,
refrain from degrading,
and encourage all blacks to be celebrated.

Commentary:

"The Complexion Battle" was written shortly after an event on campus, which I did not attend, that involved a discussion on light-skinned versus dark-skinned people. I heard about how the event went and some of the comments that were made and I had already noticed things on Twitter like "light-skinned girls are the best" and other nonsense. I took everything I was hearing and observing and wrote this poem.

It became a poem about black people, to black people which I don't often write but I felt it was important to send a reminder that it's already enough dividing us and that our focus should be on uniting. I wanted everyone to know that they are beautiful and special

and that there is nothing gained in making someone feel inferior.

These "complexion battles" create a lot of hurt, anger, and frustration and in a world where there's already so much chaos, we don't need this because it's unnecessary. Love yourself and focus on uplifting others, not bringing them down.

Thieves in the Night

Not long ago they broke in
through a side window,
not walking on tiptoe
but moving with speed
because they knew
time was limited for their devilish deed.
Their selfish, adolescent hands
snatched TVs, laptops, and
expensive jewelry
and they trashed the place
because of its tranquility.
They left as quickly as they came,
careful not to leave a trace of identity
or risk being seen.
Nearby the mastermind
waited anxiously in his SUV
and as the younguns' approached,
he helped pack their new stolen belongings.

What Is Justice?
Inspired by "Justice" by Langston Hughes

We all view it differently;
whether it's life in prison,
a formal apology, or the death penalty
but most times it isn't given.

We pray on it, sign petitions,
and schedule marches in the streets
but even when the evidence is staggering
it's something we don't see.

We encourage people to speak
and not hide behind fear or apathy
and we pressure the police until we get relief
but often we're left with a hurting black community.

Commentary:

"Thieves in the Night" was a poem I wrote shortly after someone, or some people decided to break into my family's home. I remember being so angry and feeling bad because I couldn't be with my family to console them. In order to deal with the robbery, I just sat down and wrote this poem. I didn't have all the details, I'm still not sure who did it, I just wrote down all my assumptions. I think the poem turned out decent considering other things I could've wrote.

"What is Justice?" is a poem I wrote after reading "Justice" by Langston Hughes. I always look to other poets for inspiration but I was also observant to everything going on back home in Gary, the Cedar Falls/Waterloo community, and the world in general. I saw a lot of injustice and unfairness, a lot of people giving up on the judicial system, and a lot of people hurting and wanting to take matters into their own hands. This was and is true, for the black community, so that's who my poem is for.

I pray for all of those who have lost loved ones and friends. I pray for this world we live in, may it soon get better and be peaceful for everyone.

Sensational Dancer
Inspired by Maya Angelou's, "Phenomenal Woman"

Many women wonder how I do it so effortlessly.
I roll my hips and they try to imitate me.
When I explain my technique
their confusion turns to jealousy.
I say,
it's in the bend of my knees,
the spread of my legs,
the arch of my back.
I'm a dancer,
sensationally,
sensational dancer
that's me.

I walk into a house party
just as cool as can be
and when I dance
the men stare or
get closer in proximity.
Some come up behind me-
a few thirsty gents.
I say,
it's the passion in my eyes,
the flash of my smile,
the stroke of my waist
and the rhythm of my feet.

I'm a dancer,
sensationally,
sensational dancer
that's me.

Men have wondered
how it comes so naturally.
They try to take it further
but my body
I am not offering.
When I get done dancing
they wait for another opportunity.
I say,
It's in the snap of my fingers,
the nod of my head,
the rise of my breasts.
I'm a dancer,
sensationally,
sensational dancer,
that's me.

Now you understand
why I'm not loud
or why I don't 'cause a scene.
I don't jump about
spitting lyrics to a song.
I let my dancing do the talking.
I say,
it's the wave of my arms,

the strength of my legs,
the ease in my step,
the jiggle of my butt
cause I'm a dancer,
sensationally,
sensational dancer,
that's me.

Live Now & Be Grateful
Inspired by "Amazing Grace" by Maya Angelou

In our grief we don't believe "everything happens for a reason."
We start to ask questions as we struggle with our emotions
trying to find the meaning. We hold our loved ones
as if they were newborn babies,
squeezing them tight,
vowing to never leave them.
Our distracted eyes finally see them.

We wake up early Sunday morning
to enter into His kingdom, hoping
he'll hear our backslidden cries and grant
us a long life in a wicked world
where many are dying and losing their minds.
Our souls finally seek Him.

We push aside everything that makes us unhappy,
no longer settling for a mediocre living
and seeing no better time than now
to pursue our dreams and extend our capabilities.

We rediscover the benefits of life
often out of tragedy, but don't wait
until it's too late to be a grateful being.

Funeral (Transformation)
Inspired by Ted Kooser's "Mourners"

Family and friends gathered
to say goodbye to the weights of life
that once held her down.
One by one, they rose to speak,
saying R.I.P. to her old being.
To depression, loneliness, and self-defeat
they said so long
and to a past filled with painful memories
they assured her it wasn't her fault.
To unforgiveness, self-pity, and insecurities;
they denounced its authority
and they sang songs of joy and peace.
Tears were shed but from rejoicing
and they all hugged her,
fully embracing the new woman she was becoming.

Commentary:

"Funeral (Transformation)" was inspired by poet, Ted Kooser's, "Mourners." I tried to mimic his simplistic way of writing. I thought back to when I first got saved and how incredible that experience was. I think I was 14 at the time and I remember being at the alter with all of these people around me. Some were close to me touching my back, or my shoulder and others were further away but they were all in faith praying for me and crying. It was something I wasn't used to. One of those people was my aunt. She was kneeling down at my feet, praying and crying and that image was unforgettable. I felt so loved and protected. I felt like the old me and everything that was hindering me was finally being removed. I was given a clean slate. That experience was so liberating and one I probably will never forget.

Long Distance Doesn't Work

Despite the sweat dripping from our foreheads
and the stinging pain from our red hands,
we constantly pulled each other
in a game called tug of war.

With heavy breathing
and shaking in our arms and feet,
it was obvious we were losing energy.
The demands for more visits and more intimacy
were beyond our reach.

But we continued tossing each other to and fro
afraid of losing our investments
and being alone. We had the mindset
that things would eventually get better
but conversations decreased
and it was in the moment of giving up
and letting go of the rope, that we gained the most
relief.

Can You Keep a Secret?

Last night I fell asleep peacefully in his arms
under black sheets.
This morning I woke up and put on yesterday's
clothing feeling disgusting.
I knew the sunlight coming through the blinds
could only mean one thing:
it was time for me to confess my infidelity.
Swallowing hard as if to gulp down my fears
I glanced at him and told him to take me home.
The closer we got to my dorm,
the harder I fought back the tears
starting to form in my eyes.
With each passing street came a memory
of how great things used to be...
the night he spoiled me on my birthday
and the day he gave me his favorite ring.
His car finally stopped
but my mind was rapidly moving.
Moving my lips, but unable to form
a smile, I said goodbye with my head down.
As I walked through the illuminated hallway
it felt like I was walking toward God
on judgment day. My footsteps were slow
and heavy and I could hear my heartbeat
racing. Unlocking my door with sweaty
hands, I sat on the floor praying for another chance.
I made the call and after one ring

I heard his voice that I loved so much.
Hey baby, what happened to you last night?
"Oh I was tired, so I went to sleep early."
I said it despite the guilt inside of me
knowing this was a secret not worth telling.

Cheater

You may want to erase our relationship from your
memory and forget about me, but I ask
that you don't. Not because I'm still in love
or because I had your heart, but because
I taught you a valuable lesson.
Through lies, selfishness, and acts of
unfaithfulness I became what you didn't want
and if you remember me,
I'll serve as a reminder
of what you refuse to accept from the next one
and everything that is not love.

Love

It pursued me like a thief in the night,

stealing my heart and increasing my fears.

It made me more vulnerable than I

had ever been and reminded me of

my horrible past experiences.

Naked and exposed, I stood defenseless

while it tore down the wall I built years ago;

the wall I swore would stay up so people

couldn't hurt me. With piercing eyes it looked

right through my soul and demanded a change;

demanded that I come out of my shell

and remove the bitterness that remained.

Its cunning eloquence slowly lured me

in and I couldn't escape. With nowhere

to hide, I stared the unpredictable

concept in the face. My hands began to

shake and my heartbeat became abnormal.

Nausea ensued and my legs felt weak.

I wished this "love" thing had overlooked me

but its power was inevitable

and I had to embrace it at some point,

so there I was, looking elsewhere, avoid-

ing and "love" had finally captured me.

Dreamer

I know it sounds creepy
but sometimes I watch you when you sleep.
I outline the curves of your lips,
count the freckles on your nose,
glance at your fingers and
watch as your chest rises slowly.
I listen as you snore and sometimes
find it rather amusing.
I stare at the veins and muscles
in your arms and predict
how many lines are in your palms.
I observe your eyes and the little wrinkles
above and below them. I listen
as you breathe and check to
make sure you're not blinking.
As you sleep,
I admire my dream.

With Him

With no words he speaks to me.
With one touch my heart skips a beat.
With one look, I'm mesmerized
and with one kiss I get butterflies.
With one smile I'm lost in a trance.
With one hug my heart begins to dance.
With the sound of his voice my mind is at ease.
With the mention of his name I am at peace.

With one glance I'm assured all is well.
With every love song, my feelings they tell.
With the thought of him, I smile inside.
With him next to me, I feel so much pride.
With each passing day my feelings get deeper.
With every conversation I know he's a keeper.
Man, I don't know what he's doing to me.
I feel like SWV 'cause I get so weak.
I haven't felt this way in a long time.
All I know is, I'm glad to be with him.

What Love Costs
Inspired by Maya Angelou's, "Touched by An Angel"

Me, unaccustomed to taking risks
fled from isolation
and long nights of loneliness
to let love manifest itself
and withdraw me from my
present state of independence.

Love came quick
and I buried my true feelings
due to old memories
of pain that outweighed
my current state of happiness
but slowly it wiped away my fears
and suspicion.

Both of us dismissed our hesitation
to build on trust and honest communication.
We dared to be brave
and enter into the unknown
to discover that love is good,
it is possible,
and sometimes
it "costs all we are."

Commentary:

As you can see, I've written many poems about love and it's a concept I've always tried to grasp. I've read so much about it, especially in the Bible and I've been blessed to experience it in many different ways and relationships. I think love is a beautiful thing but often gets confused with things like lust and infatuation.

The love I cherish most is that which comes from God and my family. The couple of times I have been in love, I will always remember them and cherish them. Love has had a way of changing me and I'm grateful for everything it has taught me. I don't live with any regrets and I'm excited to see what the future holds.

Too Cool
Inspired by Gwendolynn Brooks's "We Real Cool"

We rep gangs.
We carry guns.
We steal cars.
We sell drugs.
We skip school
and miss curfew.
We flaunt tattoos
and sag low.
We die young
trying to be cool.

Chance of Rain

The weather in Iowa is ridiculous.
One minute the sun is out and it's warm,
the next minute snow is falling
and it's freezing cold.
On top of that, the wind is crazy.
It literally moves me.
I never know when to pack up the winter boots and coats.
Now-a-days I just go with the flow.
I've accepted the fact that Iowa weather is unpredictable,
but one thing that has been consistent lately
is the tears on my pillow...

Loneliness, Distance, & Depression

Hearing my phone vibrate, I know it's him.
His Facebook picture pops up on my screen
and I grin. He tells me he's at the gym.
So you're all sweaty and stinky I glean?"
He laughs. Oh how I wish I could be there
to see his dimples right now. Then maybe
I'd laugh too! My depression has flared where
I'm alone. No kin, nor him-my baby.

"Baby, are you there?" he asks. "Yes, I'm here."
Holding back tears, I tell him to call when he's
done. "Is something wrong?" No, I lie, but I hear
his doubt. "I love you," he reassures me.
"I love you too…" Hanging up, I place my plate
on the dinner table and ponder my fate.

Insomnia

There are nights when my trials
keep me awake longer than I'd like.
With burning red eyes, I toss and turn while
thoughts clutter my mind.
Questions of my purpose,
worries about my family, and ways to make money
are the usual.

I reposition my head on my pillow
and attempt to get cozy underneath the covers
but nothing helps my spirit that is too often low
and instead of sleep, I lay still
and I try to be quiet so no one hears.
I pray and talk to my Father
but sometimes it seems not even He
can relieve my insomnia.

Commentary:

"Chance of Rain," "Loneliness, Distance, & Depression," and "Insomnia" were poems I wrote shortly after I was diagnosed with depression. I saw many doctors and they all gave me different types of medicine to see what would work best. At that time I was also required to go to counseling sessions on campus and for a while I couldn't stay by myself.

I remember visiting home one break and my mom was on the couch in the living room and I said, "I have something to tell you." I went and grabbed all of my medicine. I began explaining that I'd tried to take my life, that doctors had tried to send me away but I'd reassured them of my safety, and been going to counseling. All I could see was fear and worry in my mom's eyes as she cried. I knew she had to be wondering why I didn't tell her sooner but I couldn't. My mom and I sat on the couch and cried. She held me so tight and I just kept telling her, "I'm okay. I'm okay." I'm not sure how we moved on from that conversation but I felt a relief finally telling her what was going on.

Depression and suicide are serious issues that unfortunately get overlooked. There's so much stigma attached and judgment involved that people don't seek help. You can't put a face to depression which makes it harder to detect, but I ask that you pay

attention to your loved ones. For me, I stayed sad for very long periods of time over things that others would brush off. I didn't enjoy the things that I was once passionate about. I constantly isolated myself and allowed my thoughts to torment me. I was very hard on myself and would only say self-defeating things.

God, counseling, and my family have all helped me to take control over my life. I still have my moments but I am determined to never give up. No matter how much I may not understand in life or how often things may change, I will keep living and keep moving on. Life is truly what you make of it and the easiest thing to do is quit but I refuse. I cast down the spirit of depression and suicidal thoughts for anyone dealing with it and I thank God for life. There is a purpose and a plan he has for us that we may not see, but just keep living and I guarantee He'll reveal it. Be encouraged!

In the Event of My Death
Inspired by Tupac Shakur's, "In the Event of My Demise"

In the event of my death
whether I'm at home or on a hospital bed
but still my heart has stopped beating
I hope that I'll have truly lived
and by most, earned respect.

In the event of my death
whether I be young or old
but still have stopped breathing
I hope that I'll have been a woman of my word
who accomplished all her goals and dreams.

In the event of my death
when I've done all I can
and my Savior has called me to rest,
I hope that they won't spread lies
or try to resurrect my past.

In the event of my death
when my friends and family have gathered
to share memories, I hope that they won't cry
but dance and sing
and be able to say they were proud of me.

Life Is Good
Inspired by Langston Hughes's, "Life Is Fine"

I went to the dresser
and looked at the pills.
I swallowed them all,
for nothing else could heal.

Give them to me!
Give them here!
My brother sluggishly yelled
while my hands shook in fear.

That was the first time. I didn't take enough.

I went to the medicine cabinet
and I grabbed a few more pills.
I took more than I should have
because I didn't like myself.

My head began to ache
as I sat down and cried
but after some time I rose for help
because I didn't want to die.

That was the second time. I couldn't do it.

So since I'm still alive
He must have a plan.
I could've taken more and succeeded
but He had me in His hands.

Though you may see me shaking
and hear me crying,
I'll be doggone if I give up again
and you hear about me dying.

Life is what you make of it. Don't quit. Life is good.

Acknowledgements

To my Heavenly Father, thank you for the many gifts and talents you've given me to use for your glory and to bless your people. Thank you for inspiration from all your creations. Thank you for your provisions, your mercy, and your favor. Thank you for clarity concerning my purpose. Thank you for everything you've done, what you're doing, and what's yet to come. I hope I make you proud. I love you!

To my love; my mother, thank you for believing in me and supporting my dreams. Thank you for being a positive example of what a woman should be and for going above and beyond your role as a mother. Thank you for every piece of advice and all your prayers. I love you.

Gma J, thank you for making sure I have God as my foundation. Thank you for never giving up on me and for all your prayers. Thank you for your warm, loving spirit and for being who you are. You're the glue that holds our family together and you're very special to me. I love you.

Tiesha, thank you for being a great role model and an amazing sister. Thank you for all the conversations that have forced me to examine myself and change for the better. I love you so much.

To all of my other family members, you all have been my motivation to succeed in life. Thank you for your encouraging words and support. You're always in my thoughts and prayers whether you're near or far. I love you!

To Marq, thank you for always being there for me and keeping my head above water. Thank you for elevating my ambitions, your guidance, your faith in me, and your patience. Thank you for being you and lastly, thank you for helping me with the title of this book. You're my right-hand man. I love you, sweetheart!

To Dymeata Burum, thank you for believing in my work and publishing my first book through your company, bBold Publications. You gave me all the resources I needed and we finally made it happen. I know this is just the beginning and I thank you for your help, prayers, and excitement throughout this process. I know many blessings are coming your way because you're a blessing to others. I look forward to working with you again in the future.

To Jeremy Schraffenberger and Dr. Scharron Clayton, thank you for taking the time out to read my collection and for providing the blurbs on the back cover. You two have had a positive influence on my life academically, personally, and professionally. I'm glad I got a chance to share this achievement with you. Thanks again!

Thank you to Joshua Mitchell for my beautiful photos and Antwone at Graphics United for my amazing book cover.

Advice to Poets:

Be observant
Follow examples from other great poets
Take poetry classes
Go to poetry workshops
Do research to learn more about the craft
Always be writing, even if you have to come back to it
Don't believe that all poems have to rhyme
Let your poems lead you sometimes
Get familiar with your work; read it, listen to it, recite it
Be honest with yourself

About the Author:

Jerica Crawford is currently attending The University of Northern Iowa (UNI) with a major in Communication Studies and a minor in Creative Writing. She began writing poetry in her early teens, mostly about God, family, and other interpersonal relationships. Her topics evolved at UNI as she started to learn more about the craft and look to other poets for inspiration.

In the summer of 2012, Jerica began producing her own poetry segment, "Poetically Speaking" on KBBG-FM 88.1 in Waterloo, Iowa. She performs in the Midwest area when given the opportunity and she hopes to one day tour at middle and high schools, as well as universities.

Poetically Speaking: Finding Life Through Words